Edward Hopper

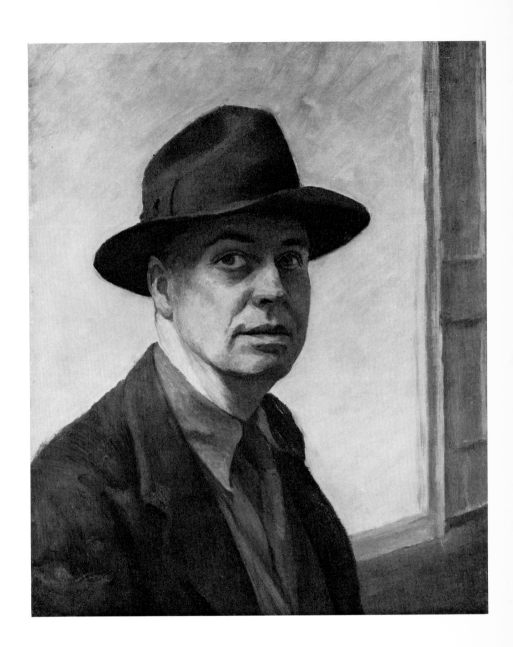

Edward Hopper

SELECTIONS FROM THE HOPPER BEQUEST TO

THE WHITNEY MUSEUM OF AMERICAN ART

By Lloyd Goodrich

EXHIBITION AND CATALOGUE BY
THE WHITNEY MUSEUM OF AMERICAN ART
NEW YORK

Published by the Whitney Museum of American Art

945 Madison Avenue, New York, N.Y. 10021

Exhibition dates: September 10–October 25, 1971

Research by Elizabeth Tweedy Streibert

Library of Congress Catalogue Card # : 79-171022

Designed by Joseph Bourke Del Valle

Printed in West Germany by Brüder Hartmann

Photography by Geoffrey Clements and Taylor & Dull

Cover: High Road. 1931. Watercolor. 20×28.

Frontispiece: Self Portrait. Oil. 25^1/$_8$ × 20^1/$_4$.

Edward Hopper

EDWARD HOPPER was a pioneer in the realistic portrayal of the American scene. In a creative career of sixty years he painted the physical actualities of the twentieth-century United States with uncompromising truthfulness. But he was more than merely an objective recorder. His images of America were charged with subjective emotion, with combined love and relentless realism that gave his art intensity and depth. And these images were embodied in works which through form and color attained plastic design of great power.

In the early 1900's academic American painters were picturing our country with sentimental idealism, selecting its idyllic aspects and ignoring the evidences of man and his works. If they occasionally painted the city, they chose its stylish sections. Few artists had attempted an honest portrait of our land and what we had made of it.

This academic idealism was being challenged by the group of young urban realists led by Robert Henri. It was in the Henri camp that Edward Hopper had his artistic beginings—but with a difference. As early as 1908 he was painting everyday features of the contemporary scene—railroads, el stations, tramp steamers, tugboats—that none of his colleagues were interested in, subjects devoid of human interest or glamor. Already his vision and style were essentially those of his later works, though less developed.

In the meantime he made three long visits to Europe between 1906 and 1910, spending most of his time in Paris, painting and drawing the city and its people. His cityscapes were akin to impressionism in their preoccupation with outdoor light and color, but unimpressionist in their emphasis on massive architectural forms. "The light was different from anything I had ever known," he later said to Alexander Eliot. "The shadows were luminous—more reflected light. Even under the bridges. . . . I've always been interested in light—more than most contemporary painters."

Quite different from these cityscapes were his many watercolors and drawings of Parisian life in streets and cafés, including a series of watercolor caricatures of boulevard types that showed a vein of broad humor. These graphic works reveal a lively interest in French popular life that one would not suspect in an artist who was later to be so completely devoted to the American scene. In these years the Paris art world was seething with revolutionary movements, but they had no perceptible effect on Hopper. After his third European stay in 1910 he never went abroad again.

Back in his own country he soon found that his kind of realism was too unromantic for the academic juries of the big exhibitions through which alone a young artist could show his work in those days. After repeated rejections he gave up submitting; and from about 1915 to 1920 he painted less,

although he never stopped entirely. Since leaving art school he had made his living by part-time work in advertising and illustration—work that he hated. As he once said to me, he wasn't interested in drawing people "grimacing and posturing. Maybe I am not very human. What I wanted to do was to paint sunlight on the side of a house."

But Hopper was too strong-willed to accept defeat. In 1915 he took up etching, and in the sixty-odd plates of the next eight years he first said in a fully mature style what he wanted to say about the world he lived in. Here were familiar aspects of the United States pictured with utter honesty and direct vision, and an undertone of intense feeling. In their transformation of reality into imagery alive with emotion, their strength of design, and their economy of means, these prints were the work of an artist who, within the limits of black and white, had finally found himself. They were his first works to achieve success: after a few years they began to pass academic juries, and even won prizes.

So far Hopper had sold only a single painting, a small oil from the Armory Show of 1913. But about 1920, evidently encouraged by the reception of his etchings, and by his first one-man exhibition, at the Whitney Studio Club that year, he began to paint more in oil; and in 1923 he embarked on watercolor, which henceforth was his other major medium. His watercolors sold well; and from this time his career was one of growing reputation and success.

These years brought changes in his personal life. In 1924, when he was almost forty-two, he married Josephine Verstille Nivison, who had also been a Henri student, after his time. She shared fully his beliefs and tastes, not only in art but in living. They had no children, and they liked a life of the utmost simplicity and frugality. Hopper could now give up commercial art, and they spent whole summers working in the country, usually along the New England coast. Their winter home was at 3 Washington Square North, New York, on the top floor, where Hopper had lived since 1913, and where they remained the rest of their lives.

In 1930 they bought land at South Truro on Cape Cod, and built a simple shingled house on the high moors looking over Massachusetts Bay. Thenceforth this was their summer home for about six months, with some travelling by car within the United States, and later, from the 1940's, in Mexico. After 1930 most of Hopper's landscapes and village scenes were based on Cape Cod. The rolling sandy hills of the Cape, green with pines and scrub oaks, the great dunes on the ocean side, the white-painted villages, the plain wooden churches and farmhouses and barns, the sense of salt water on both sides, and the pervading light—all these made the Cape the right place for living and working.

———————

Hopper's chief subject matter was the physical face of America. His attitude toward the native scene was not simple. He once said to me, speaking of his early years, that after France this country seemed "a chaos of ugliness." No artist was more aware of the architectural disorder and monotony of our cities, the dreariness of our suburbs, the rawness of our countryside, ravaged by industry and high-speed transportation. But beneath this awareness lay a deep emotional attachment. This was his world, in which he had been born and had grown up, and to which he was bound by strong ties. Hopper was a complete realist, incapable of escape through fantasy; an artist who must create his art out of the world he knew best. In his response to this world, familiarity and love contended with negativism, and triumphed. In a basically affirmative spirit he built his art out of the common American scene, in all its meanness and largeness, its ugliness and its unintended beauty. This robust acceptance gave his portrait of America a strength and authenticity that were new notes in our art. At the same time, the conflict between the positive and the negative kept his portrait from ever becoming a flattering one, and added to the depth and intensity of its emotional content.

Hopper's subjects can be divided into three main categories: the city, the town and the country. His predecessors of the Henri group had used the American city as a background for human activity; but Hopper concentrated on the city itself as a physical organism, and its myriad pictorial possibilities: the variety of structures and objects, the effects of varying light on them, the visual drama of night lights and

shadows. There are no crowds in his city, no rushing traffic; it appears unpopulated—monumental, not dynamic. The occasional figures are parts of the whole scene, not leading actors. The closest intimacy he attained was in his recurring theme (appearing first in his etching *Evening Wind*) of a woman in a city interior, nude or half-dressed, often by a window—the intimacy of her nakedness contrasting with the vast impersonality of the city outside. She was pictured without either idealization or eroticism, yet with a full realization of her physical existence that revealed a masculine sensualism beneath Hopper's apparent detachment.

The small town and village presented another kind of material: in particular, the seaside towns of New England—the white wooden houses of early days, their puritan severity relieved by jigsaw ornamentation; or the more ambitious flamboyant mansions of the late nineteenth century with their mansard roofs, wide-spreading porches, and jutting dormers and bay windows. Never before had the American town been subjected to such candid depiction. But there was no satire; merely an honest portrayal of a typical aspect of the United States. Actually, Hopper's attitude was positive: he liked native architecture in its unashamed provincial phases, an expression of the character of a people; he liked its vitality, starkness, and naive originality. And he loved its pictorial qualities: its bold forms, the play of sunlight and shadow on them, the way a white-painted wall looked under the hot summer sun.

Since his boyhood at Nyack on the Hudson River, Hopper had been attracted to everything connected with water and boats. As a young man he had painted along the New England coast as far east as Monhegan Island, with its dark cliffs rising sheer out of deep water. At Gloucester he pictured the busy harbor, the docks and fish-houses, the rusty steam trawlers, and the sheltered coves of Cape Ann. On the rocky point of Cape Elizabeth, Maine, he found the towering lighthouse of Two Lights and the Coast Guard buildings at its foot; and further north, Portland Head Light, the oldest in Maine. All these structures had the functional beauty of things that have to do with the sea. The noble white forms of the lighthouses, seen in the clear air and strong sunlight of

Maine, inspired some of his finest watercolors and oils.

As much as the city and the town, Hopper painted the deep country. From the first his paintings broke with the idyllic tradition of American landscape. Those inescapable features of our land, the automobile highway and the railroad, and their accompanying bridges, depots, telephone poles and gasoline stations, were integral elements in his landscapes. To him they did not detract from nature's pictorial value, but enhanced it. He liked the relationship between the irregular forms of nature and the regular forms of man-made things: the straight lines and mathematical curves of highways, the undeviating horizontals of railway tracks, the stark angles of farm buildings. Often the horizontal line of a road or tracks formed a solid base for the richer, more complex natural forms beyond and above.

As in all his pictures, light played an essential role in his landscapes. But he differed from impressionism in never allowing the solid substance of objects to be dissolved in luminous atmosphere. Whereas the American impressionists had imported the soft air and light of France, he recorded the clear air, strong sunlight and high cool skies of our Northeast. Everything in his landscapes is seen with complete clarity. There is no softening of edges, even in twilight and night scenes. Lights and shadows are sharply defined and strongly contrasted. Light is an active force: streaming into the scene, it falls on forms and models them, produces precise patterns of light and shade, acts as a dynamic element in the whole pictorial concept. And the quality of the light, the particular hour and season and weather, determine the mood.

In Hopper's art, realism was combined with strong subjective emotion. His portraiture of actualities was always true and accurate; but it would have been sterile without the emotion with which it was charged. This emotion was concentrated not on humanity but on its environment, on the structures and objects that man has built, and on nature with its signs of man's activities. A gasoline station on a country road with night coming on, its lighted red pumps bright against dark woods and cold evening sky—this familiar image expresses all the loneliness of the traveller at nightfall. Railroad tracks cutting straight across the picture, a signal

tower and semaphore dark against a fiery sunset—nothing more, but a feeling of utter isolation. The rolling moors of Cape Cod on a summer afternoon, when the raking light and long shadows and crystal-clear air are filled with a penetrating sense of solitude and silence. In exactly conveying the mood of these particular places and hours, Hopper's art transcended realism and became highly personal poetry. His poetry was never sentimental; it had too direct a relation to actualities. Where a sentimentalist would have made such themes banal, with him they were completely fresh and genuine. Banality, indeed, was inherent in much of his subject matter, but the strength of his feeling for familiar reality transformed banality into authentic poetry.

Hopper's style was entirely naturalistic; his vision was close to that of the "normal" person, his scenes and objects were based on actual ones. But their forms were also those of art. To him there was no conflict between representation and plastic creation; the work of art could exist on several levels —on those of both realistic subject matter and formal values. Plastic creation for him was not flat patterning but the construction of round forms in three-dimensional pictorial space. His work speaks to us in the direct sensuous language of form and color. The sheer physical power of his paintings

is a fact that strikes us immediately. They exist, with a natural, unforced substance and strength. His forms are massive, simplified, stripped of non-essential details. His design is characterized by straight lines, sharp angles, and strong contrasts of horizontals and verticals. In some works, particularly of his later years, the severe formal structure has parallels to geometric abstraction—a comparison, incidentally, that Hopper did not care for.

In conversations with me he confirmed that he designed his pictures consciously and deliberately. His methods were far from literal copying of nature. While almost all his watercolors and some of his early oils were painted "from the fact," as he put it, his later and more complex oils were composed by a process of observation and re-creation of "the fact." He chose his subjects with great care, spending a long time studying motifs in the "real" world and making many sketches of them. From these sources, elements were selected, combined, and transformed into the composition to be realized on canvas. Thus the final result was a composite image, based on specific realities but transcending them. By this creative process Hopper achieved what was essentially subjective imagery—the image of the mind's eye—embodied in plastic design.

10

The Hopper Bequest

THE RELATIONS BETWEEN Edward Hopper and the Whitney Museum were long and cordial. Indeed, they began years before the Museum was founded. When the Whitney Studio Club, forerunner of the Museum, was started by Gertrude Vanderbilt Whitney in 1918, Hopper was one of the earliest members. Then in his middle thirties, he was still an unknown; he had stopped trying to exhibit, had no dealer, and was supporting himself by commercial art. In 1920 the Club gave him his first one-man exhibition, of the oils he had done in Paris from 1906 to 1909. Two years later came a second show at the Club, of his Paris watercolor caricatures. From 1920 he was included in the Club's annual exhibitions of members' works, which soon rivalled the big academic shows.

About 1923 the Club began to hold evening sketch classes twice a week, where members could draw from the model. Katherine Schmidt, who ran the classes, remembers that Hopper attended every class as long as they continued. It was here that he made the many drawings from the nude that are among his strongest graphic works.

In the 1920's *The Arts*, supported by Mrs. Whitney, was the leading liberal American art magazine. The editors, Forbes Watson, Virgil Barker and myself, all admired Hopper's work. In 1924 Barker contributed an article on his etchings, and in 1927 I wrote an article on his work as a painter. We also discovered that Hopper himself could write

extremely well, if persuaded. Hence articles on two contemporaries he liked, John Sloan and Charles Burchfield, as well as two book reviews. Hopper wrote seldom, and never enjoyed it; "I sweat blood when I write," he said in a letter to Watson. But the final product had the thoughtfulness and substance of his painting.

After the Whitney Museum opened its doors in 1931, Hopper's oils and watercolors were included in practically every annual exhibition throughout his life. From the first annual in 1931 the Museum bought *Early Sunday Morning*.

In the middle 1940's the American Art Research Council, established by the Whitney with myself as the Council's Director, compiled a catalogue of Hopper's known works. Hopper and his wife Jo cooperated fully with the Council's Secretary, Rosalind Irvine, making available a record of his oils, watercolors and prints, kept by both of them since about 1924, in four ledger volumes, with drawings by him of each picture. The Council's project, and other friendly contacts over the years, gave me opportunities to talk with Hopper about his work and his life, and to record what he said. One result was the publication in 1950 of my small book on him, by Penguin Books, Ltd., of England, in the "Penguin Modern Painters" series, of which the American editor was Alfred H. Barr, Jr.

In 1950 the Whitney Museum held a full-scale retro-

spective exhibition of Hopper's works. Fourteen years later, being aware that he had painted some of his finest pictures in the intervening years, we held a second large retrospective which filled the entire museum building on 54th Street, and brought a remarkable response from all factions of the art world. During the exhibition I started work on a full-length book on Hopper, now being published by Harry N. Abrams, Inc. I am glad to say that the Hoppers knew of the plans for the book.

After Edward Hopper's death in 1967 and that of Mrs. Hopper the following year, we learned that she had bequeathed their entire artistic estate to the Museum—a decision that both of them had made during his lifetime. In the words of John I. H. Baur, Director of the Museum, "This is probably the most important bequest of an American artist's work to a museum." The collection contains over two thousand oils, watercolors, drawings and prints, ranging from Hopper's student days to his later years. Elizabeth Tweedy Streibert, Researcher of the Museum, has spent more than a year in cataloguing and photographing the works.

The cataloguing has revealed that most of the pictures bequeathed were not included in the record kept by the Hoppers. We had assumed that the record covered all his works, but it evidently covered only works sent to his dealer, the Rehn Gallery, exhibited, or sold. That he never exhibited the unrecorded pictures or put them out for sale, is a mystery. I believe that the explanation lies deep in his character. Hopper was that rare phenomenon, a genuinely modest man. He was often over-critical of his own work; he would say that a painting was not quite what he had had in his mind. This self-criticism was obviously genuine; there was sometimes a conflict between the inner image and the one on canvas. He was well-known for expressing low opinions even of paintings that others admired. On more than one occasion in his studio, at my request he would bring out a canvas from among those stacked up, and when I said I thought it was good, he would express entirely sincere surprise: "You *like* it?" Once he opened a bureau drawer and I saw that it was filled with unmatted watercolors. When I suggested that the top one was good enough to sell, he was again surprised, but

sent it to the Rehn Gallery, where it soon found a purchaser.

So with some exceptions the Bequest consists of works never recorded, exhibited or reproduced. They cover every stage of Hopper's career, and every medium he practised. The American oils range from *El Station* and *Tugboat* of 1908 to his Cape Cod scenes; the American watercolors, from 1923 to his two last known pictures in the medium, 1962 and 1965. While some of the numerous watercolors are unfinished, the majority of the oils are as complete and fully realized as the works he exhibited and recorded.

Just when he painted the many unrecorded works is a question. We have dated them, sometimes approximately, by their resemblance in subject or style to his recorded works. Although Hopper usually signed his pictures, he almost never dated them, which may seem odd in view of his meticulousness in other respects. His chief reason, I believe, was that since so many remained unsold for years, if they were dated people would wonder why they were still on his hands.

The Bequest reveals several aspects of Hopper's art that are not generally known. For example, his student paintings; he evidently saved a large part of them. They show him as technically skillful in the direct, broad-brushed Henri style, with a good sense of character.

His oils, watercolors and drawings done in France from 1906 to 1909 are very fully represented in the Bequest. Since the Whitney Studio Club exhibitions of his French pictures in 1920 and 1922, only a few of them have been shown, and fewer have been sold; so the Bequest evidently includes almost all his French works. The larger oil cityscapes of Paris, with their luminosity and fine color, constitute a phase of his art that deserves to be better known than it has been. Other French works present some surprises, even for those of us who thought we knew his art: for example, the attractive smaller oil city scenes; the numerous watercolor caricatures; and the strong black and white drawings of Parisian life. It is tantalizing to speculate about the three striking posterlike watercolors of scenes during the Paris Commune of 1870–1871, titled *L'Année Terrible*; perhaps they were intended as illustrations. Then there is the unrecorded oil, one of his largest, *Café Scene*, which is obviously French in subject, but

which in view of its resemblance in style to his American work, is probably a reminiscence.

The Bequest includes practically all the drawings from the nude preserved by him from those he made in the Whitney Studio Club sketch class in the 1920's. Almost all are of women; male models were probably harder to get. These drawings show not only a thorough knowledge of bodily structure but a gift for capturing momentary poses and gestures, and a feeling for the living female body—qualities that were not always present in his figure paintings, and that may be surprising to those who think of him as a portrayer of inanimate scenes and objects.

There are seventy-six etchings and drypoints, including several prints of some subjects. The Bequest also includes sixty-one plates, of which eleven were etched on both sides— probably the plates for all his prints, of which a number are unrecorded. Hopper fixed the edition for each of his prints at one hundred, but his record books show that only a few of the most popular were printed to even half that number.

The numerous drawings for his major oils furnish a unique record of his methods of composition. They begin with many on-the-spot sketches of places and objects; for *New York Movie*, for example, there are fifty notes of the interiors of several theaters, down to minor details. The over-all composition was then developed in a larger drawing, or series of drawings, the final one showing the whole design much as it was to be executed on canvas.

The Hopper Bequest establishes a corpus of his work in all its phases such as does not exist, to our knowledge, for any other American artist. It will enable scholars, students and the general public to study his lifework in every period and medium, and through his preparatory drawings to trace his methods of creation. And for the enjoyment of everyone it will make available a collection of largely unknown works of wide variety and high quality by a major American artist. The Whitney Museum is deeply grateful to Edward Hopper and Josephine Hopper for their generosity and foresight in making this magnificent bequest.

Biographical Note

EDWARD HOPPER was born on July 22, 1882, at Nyack, N.Y. He attended a local private school, then Nyack High School. In the winter of 1899–1900 he studied illustration at a commercial art school in New York. From 1900 to about 1906 he studied at the New York School of Art: for the first year, illustration; then painting under Robert Henri and Kenneth Hayes Miller.

In October 1906 he went abroad for about nine months, visiting England, Holland, Germany and Belgium, but spending most of his time in Paris, where he painted and drew city subjects. He went again in the summer of 1909 for about six months, spent entirely in France, mostly in Paris, again painting city scenes. His third visit was in the summer of 1910 for about four months, in France and Spain, travelling and looking at art, but with little or no painting. This was his last visit to Europe.

From 1908 he lived in New York; from 1913, at 3 Washington Square North. After leaving art school he made his living by part-time work in an advertising agency, and some illustration, painting in his free time and in the summers: at Gloucester, Mass., in 1912; Ogunquit, Maine, about 1914 and 1915; and Monhegan Island, Maine, about 1916. He exhibited, probably for the first time, in March 1908 with other Henri students. Included in the Armory Show, 1913, he sold an oil, *Sailing*, for $250.— his first sale of a painting, and the last for ten years. Because of regular rejection of his works by academic juries, he stopped submitting; and from about 1915 to 1920 he painted less, continuing to support himself by commercial art.

In 1915 he took up print-making, producing over sixty plates in etching and drypoint in the next eight years. His prints were admitted to exhibitions from about 1920 on, won two prizes in 1923, and sold well. His first one-man exhibition, of his Paris oils, was held at the Whitney Studio Club in January 1920, followed by a show of his French watercolor caricatures at the Club in October 1922. Probably because of this recognition and success with his prints, from about 1920 he worked more in oil, and in 1923 began to paint watercolors. In 1924 the Frank K. M. Rehn Gallery of New York became his dealer, and remained so for the rest of his life. His first exhibition there, in November 1924, of recent watercolors, was a success, and a second show at the Rehn Gallery in February 1927, of oils, watercolors and prints, established his reputation.

Hopper married the painter Josephine Verstille Nivison, July 9, 1924. Their winter home remained 3 Washington Square North. Summers were spent mostly in New England: at Gloucester in 1923, 1924, 1926 and 1928; at Rockland, Maine, in 1926; and at Cape Elizabeth, Maine, in 1927 and 1929. In 1925 they made their first trip West, to Santa Fé; and in 1929 they visited Charleston, S.C. In 1930 they built a house in South Truro, Cape Cod, their summer home thereafter. They visited Vermont in 1936, 1937 and 1938; made an automobile trip to the West Coast in 1941; and in the summers of 1943, 1946, 1953 and 1955 they were in Mexico. Hopper painted watercolors on almost all these trips. Six months in 1956–57 were spent at the Huntington Hartford Foundation in California.

From the late 1920's Hopper was represented regularly in the chief national exhibitions. Major retrospectives were held by the Museum of Modern Art in 1933, the Carnegie Institute in 1937, the Whitney Museum in 1950 and 1964, and the University of Arizona Art Gallery in 1963. From about 1930 he received increasing awards and honors.

Edward Hopper died in his studio on Washington Square, May 15, 1967.

Plates

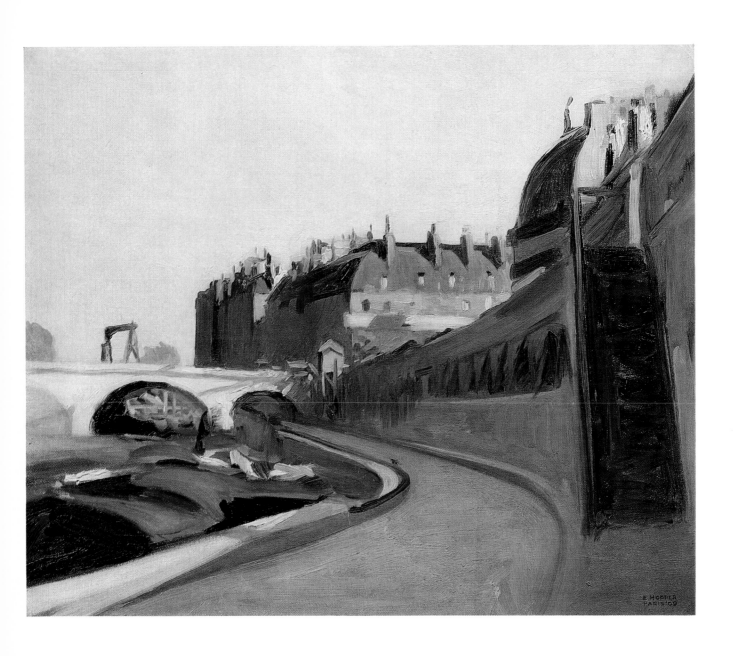

Le Quai des Grands Augustins. 1909. Oil. 23½ × 28½.

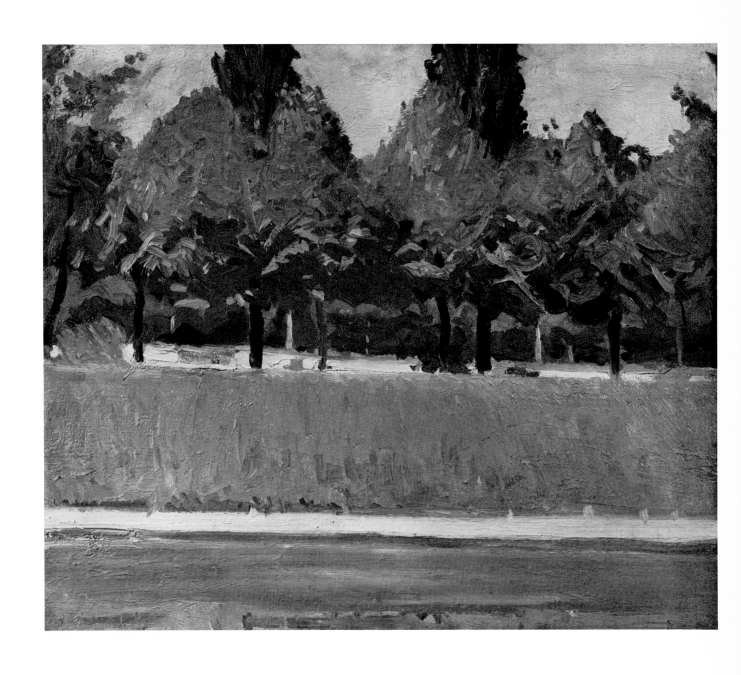

Canal at Charenton. 1906/7 or 1909. Oil. 23¹/₄ × 28³/₈.

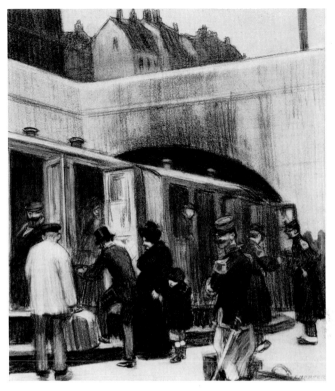

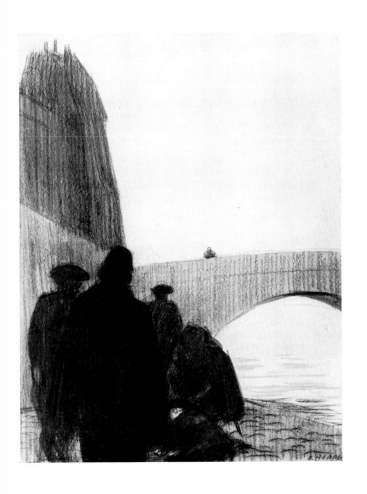

left: *On the Quai: The Suicide*. 1906/7 or 1909. Conte and
wash with touches of white. $17^1/_2 \times 14^{11}/_{16}$.
above: *The Railroad*. 1906/7 or 1909. Conte, charcoal and
wash with touches of white. $17^3/_4 \times 14^7/_8$.

left: *At the Café.* 1906/7 or 1909. Watercolor. $11^{13}/_{16} \times 9^{1}/_{2}$.
right: *Woman.* 1906/7 or 1909. Watercolor. $11^{13}/_{16} \times 9^{3}/_{8}$.

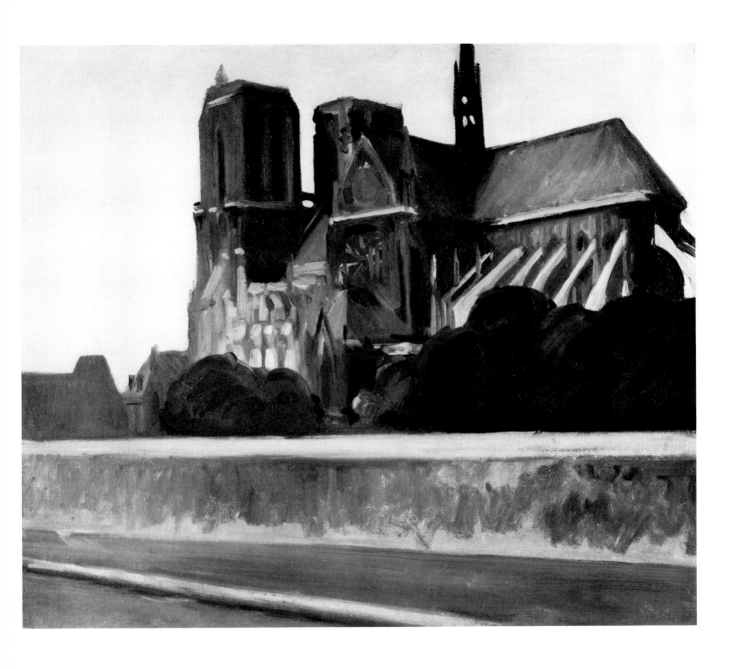

Notre Dame #2. 1906/7 or 1909. Oil. $23 \times 28^{1}/_{2}$.

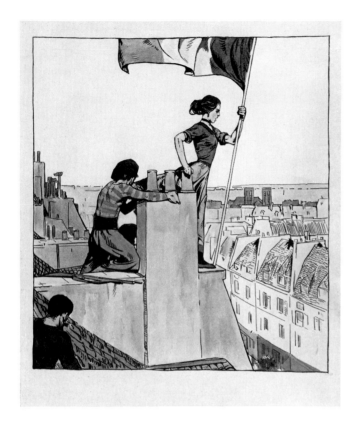

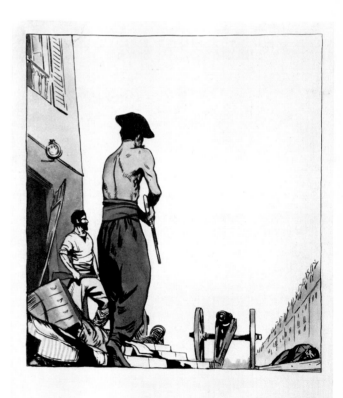

above: *L'Année Terrible: On the Rooftops.* Watercolor.
21³/₄×14³/₄.
right: *L'Année Terrible: At the Barricades.* Watercolor.
21³/₄×14¹¹/₁₆.

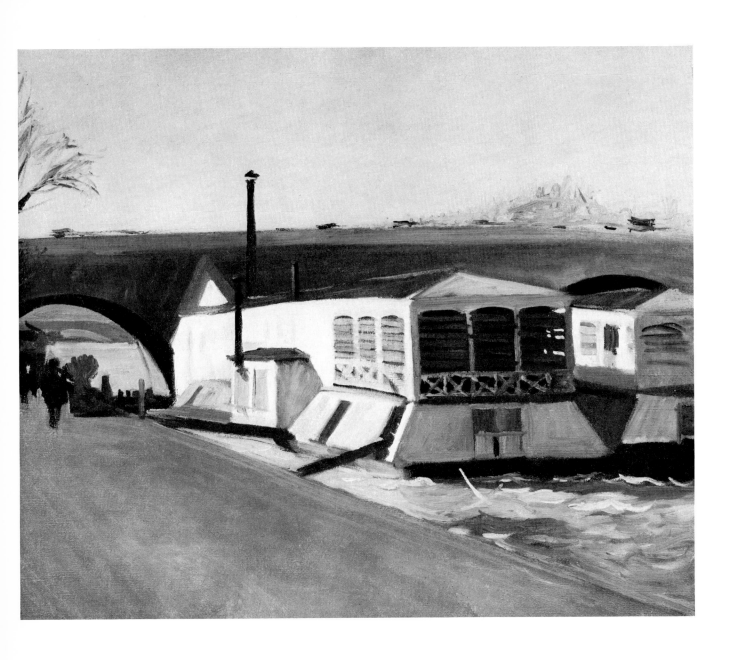

Les Lavoirs à Pont Royal. 1906/7 or 1909. Oil. 23¹/₄ × 28¹/₂.

River Boat. 1906/7 or 1909. Oil. 28×48.

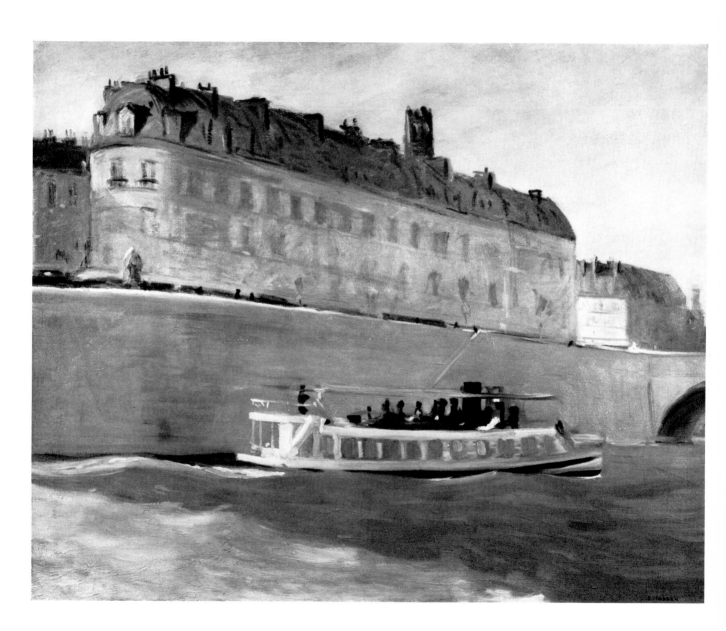

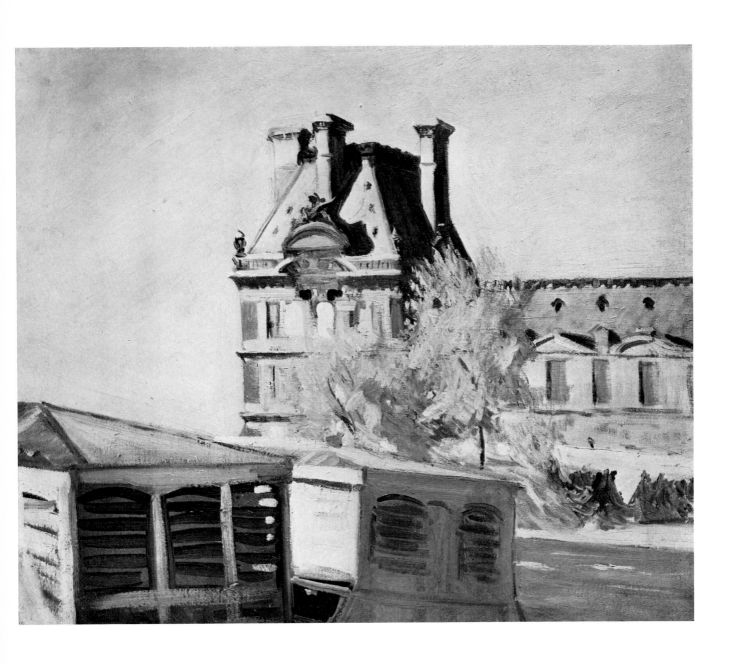

Pavillon de Flore. 1909. Oil. $23^{1}/_{2} \times 28^{1}/_{2}$.

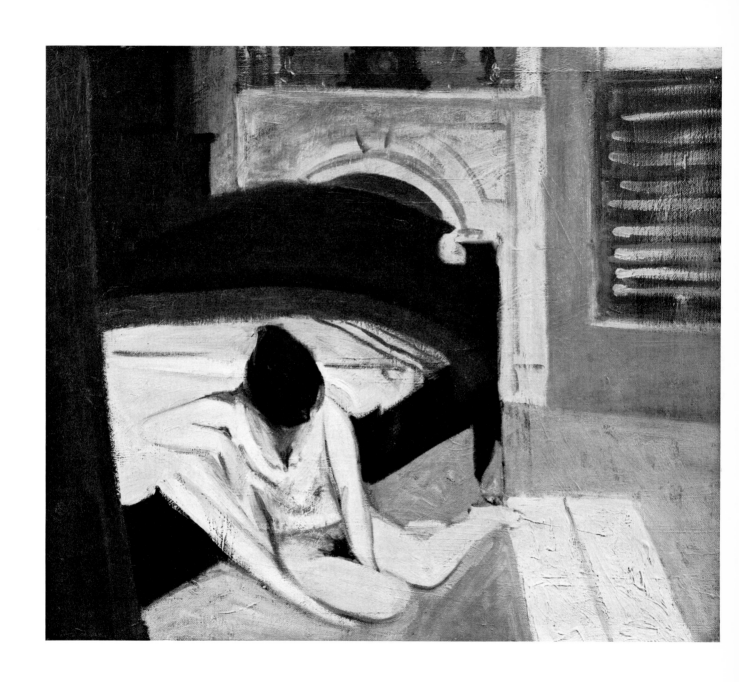

Summer Interior. 1909. Oil. 24×29.

26

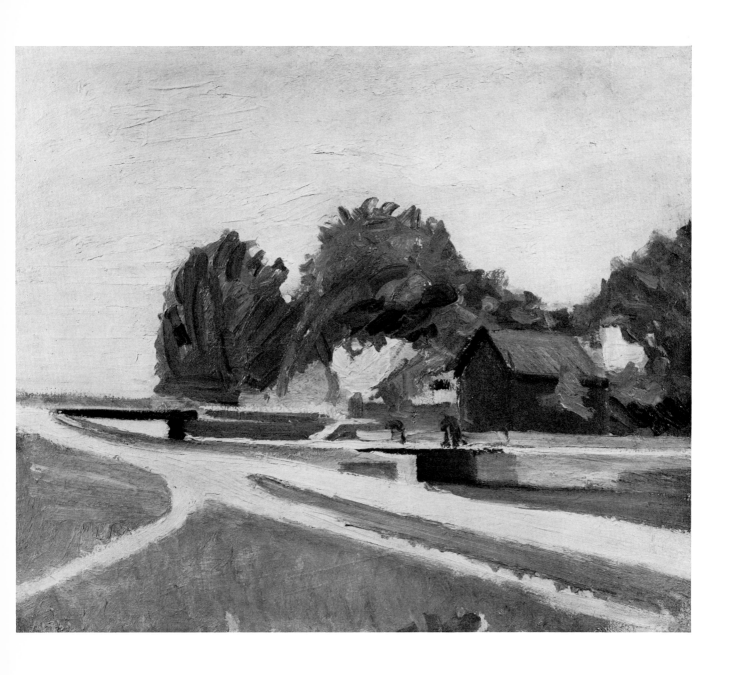

Canal Lock at Charenton. 1906/7 or 1909. Oil. 23¹/₄ × 28³/₈.

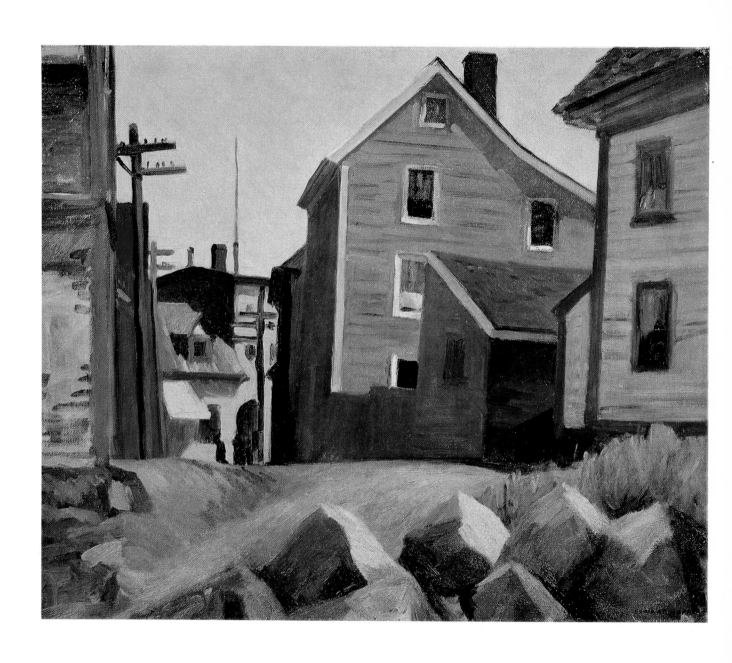

Italian Quarter, Gloucester. 1912. Oil. $23^3/_8 \times 28^1/_2$.

28

Tugboat with Black Smokestack. c. 1908. Oil. 20×29.

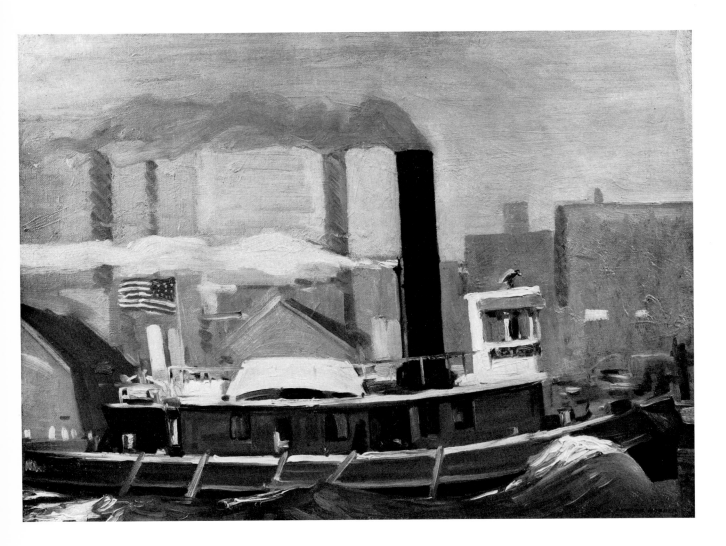

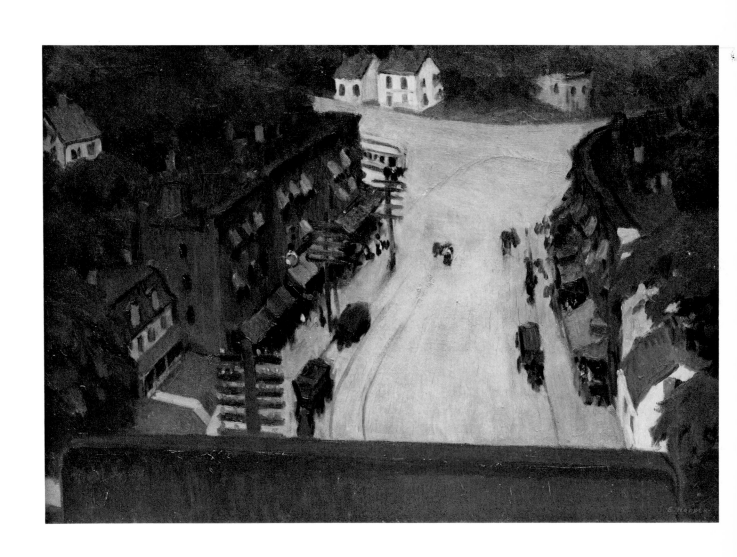

American Village. 1912. Oil. 26 × 38.

30

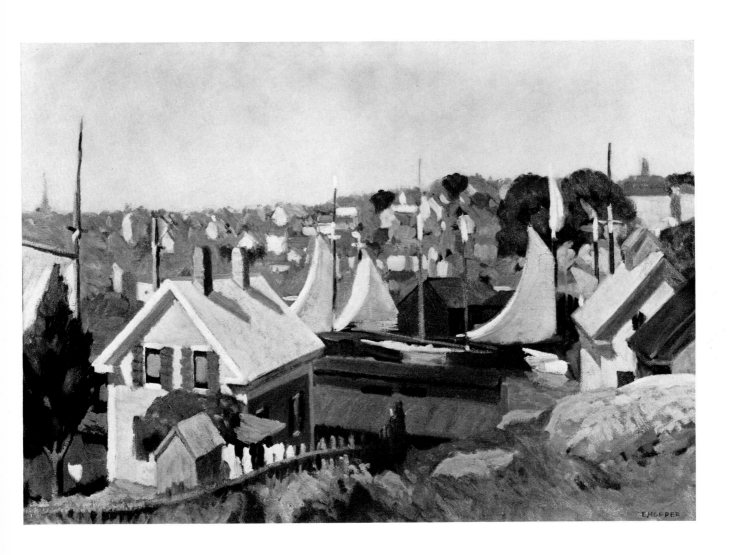

Gloucester Shorefront. Probably 1912. Oil. 26 × 38.

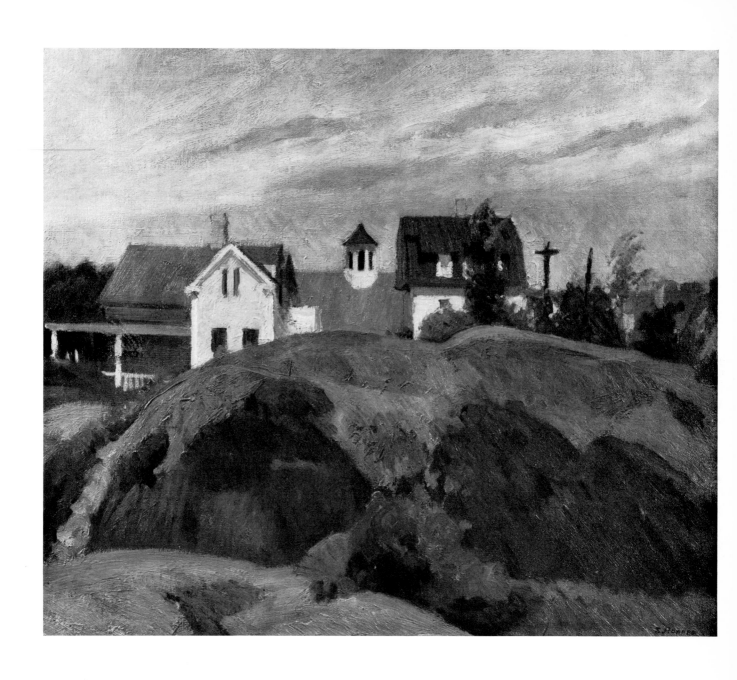

Rocks and Houses, Ogunquit. 1914. Oil. 23³/₄ × 28³/₄.

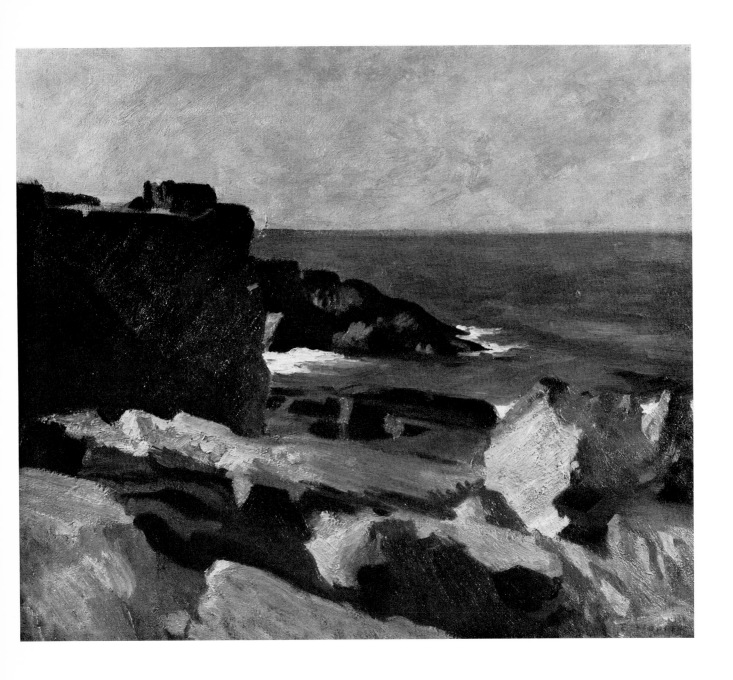

Rocks. Probably 1914. Oil. 24×29.

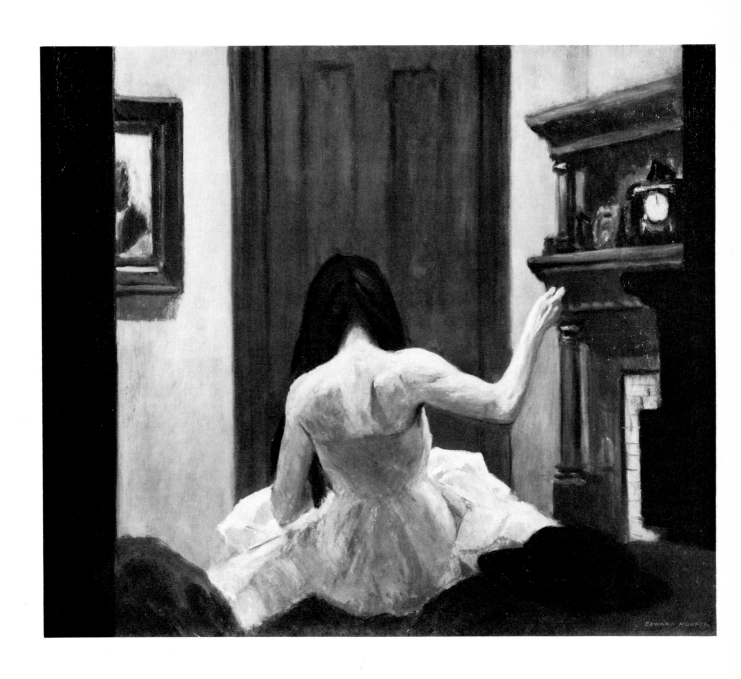

New York Interior. c. 1921. Oil. 24×29.

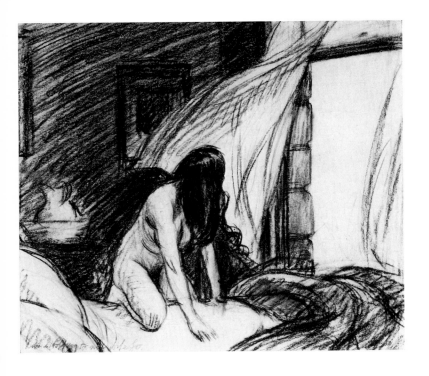

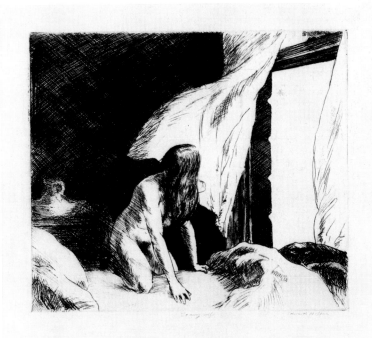

above: *Drawing for etching Evening Wind.*
1921. Conte and charcoal. $10 \times 13^{15}/_{16}$.
right: *Evening Wind.* 1921. Etching. $6^{7}/_{8} \times 8^{1}/_{4}$.

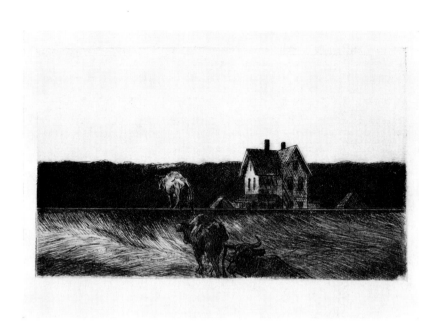

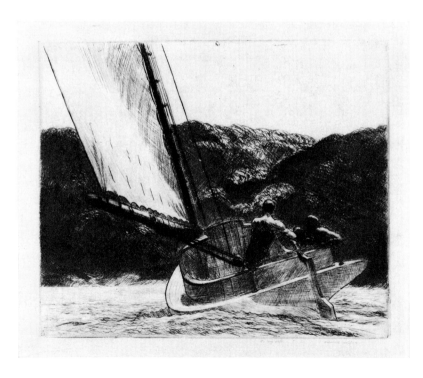

above: *American Landscape*. 1920. Etching.
7³/₄×12¹⁵/₁₆.
left: *The Catboat*. 1922. Etching. 7⁷/₈×9⁷/₈.

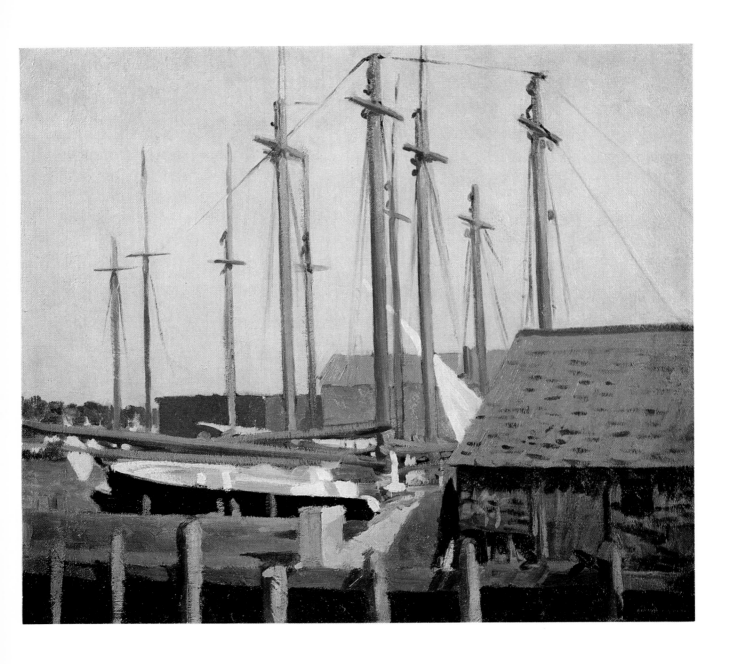

Tall Masts, Gloucester. 1912. Oil. 24×29.

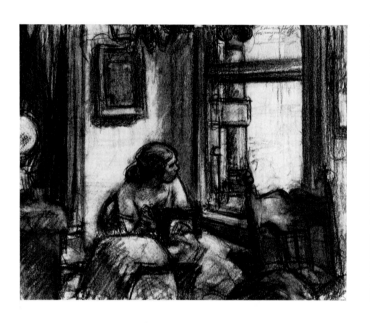 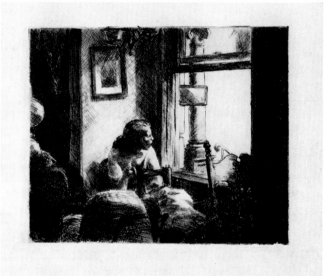

left: *Drawing for etching East Side Interior.* 1922. Conte and
charcoal. $8^{15}/_{16} \times 11^{1}/_{2}$.
right: *East Side Interior.* 1922. Etching. $7^{7}/_{8} \times 9^{13}/_{16}$.

38

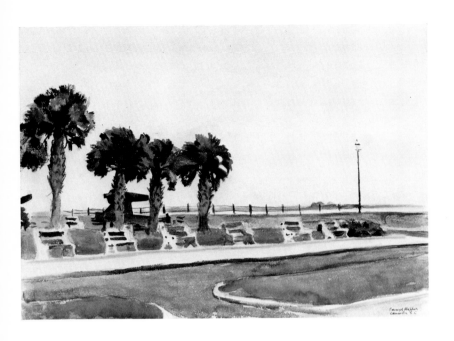

above: *The Battery, Charleston, S.C.*
Probably 1929. Watercolor. $13^7/8 \times 19^{15}/16$.
right: *Building, Southwest*. Probably 1925.
Watercolor. $13^7/8 \times 19^{15}/16$.

39

Railroad Crossing. c. 1922–23. Oil. 29 × 39³/4.

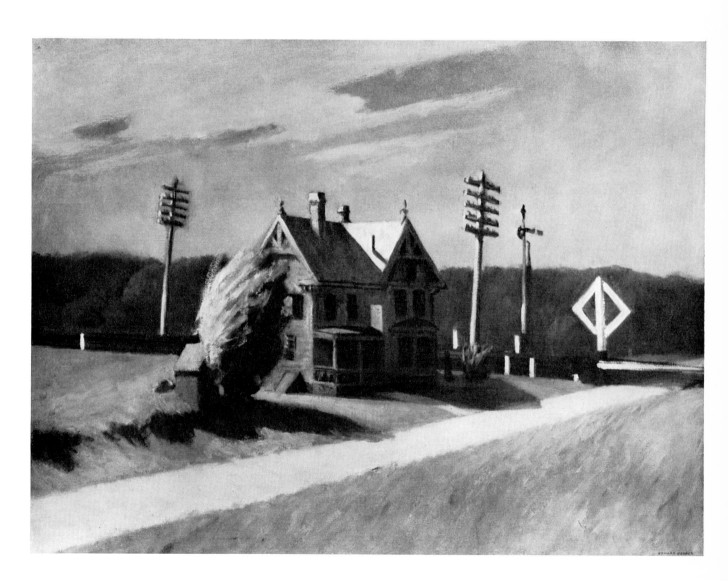

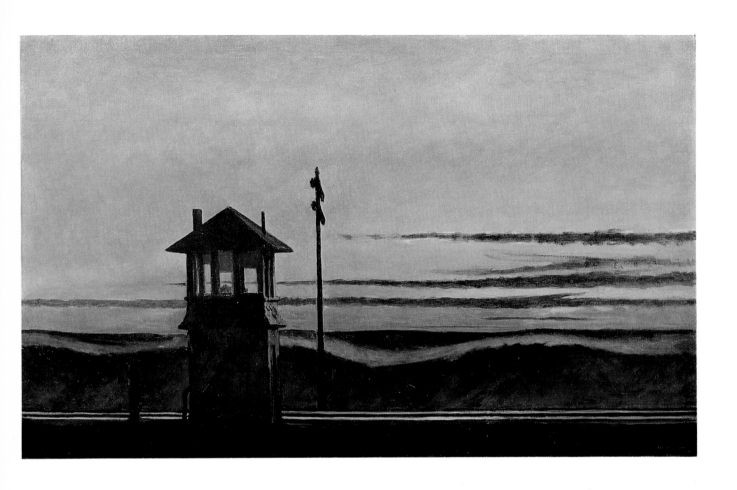

Railroad Sunset. 1929. Oil. 28¹/₄ × 47³/₄.

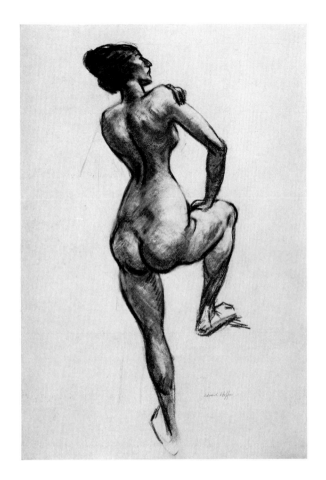 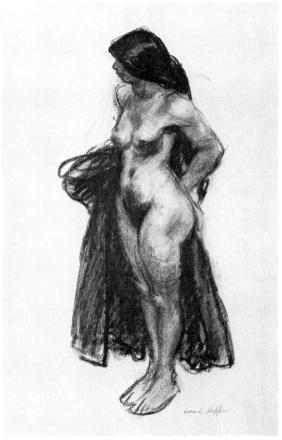

left: *Standing Nude*. Conte and charcoal. 22¹/₁₆×15.
right: *Standing Nude*. Conte. 18×11¹/₂.

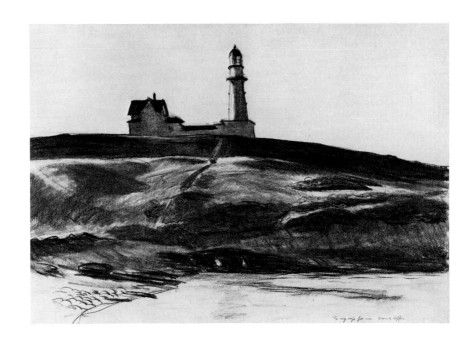

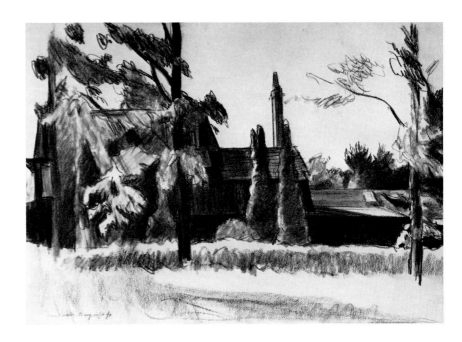

above: *Light at Two Lights*. 1927.
Conte and charcoal. $15 \times 22^{1}/_{16}$.
right: *Topsfield*. 1929. Conte and charcoal.
$15^{1}/_{16} \times 22^{1}/_{16}$.

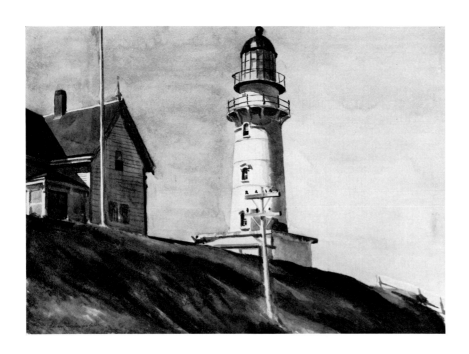

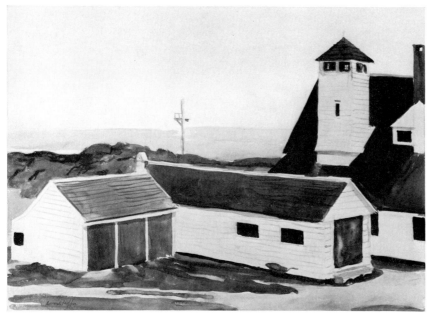

above: *Light at Two Lights*. Probably 1927.
Watercolor. $13^{15}/_{16} \times 20$.
left: *Coast Guard Station*. Probably 1927.
Watercolor. $13^{15}/_{16} \times 20$.

44

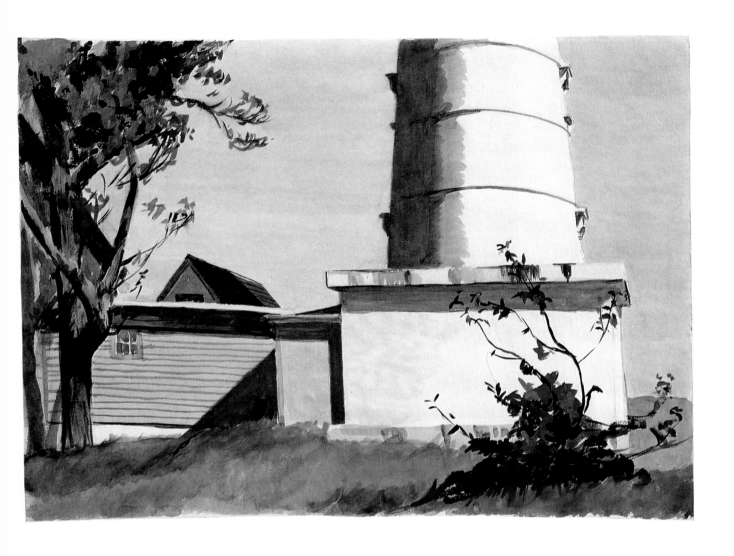

Light at Two Lights. Probably 1927. Watercolor. $13^{15}/_{16} \times 19^{15}/_{16}$.

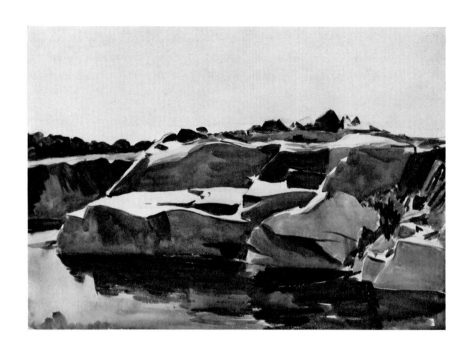

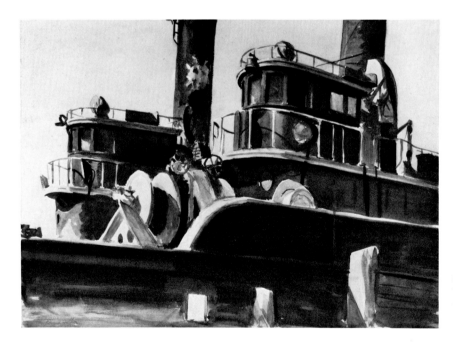

above: *Rocky Shore and Water.*
Watercolor. $13^{15}/_{16} \times 19^{15}/_{16}$.
left: *Two Trawlers.* Probably 1924.
Watercolor. $13^{7}/_{8} \times 19^{7}/_{8}$.

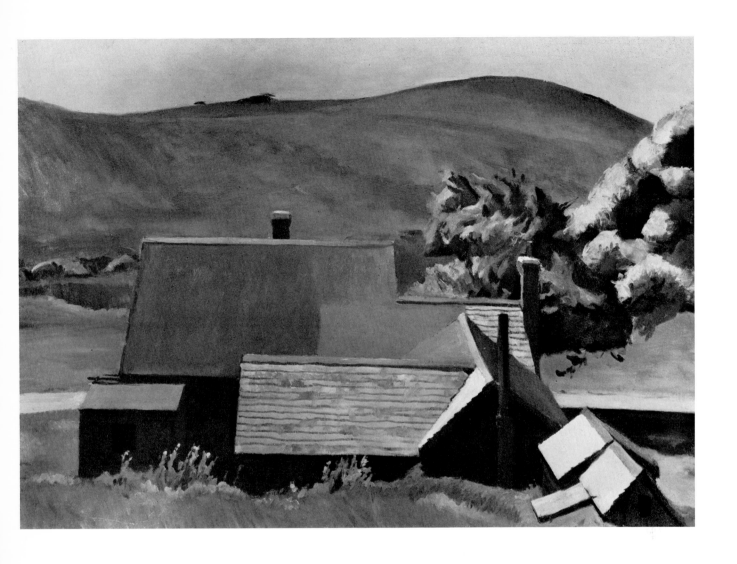

Burly Cobb's House, South Truro. Probably 1930. Oil. 24³/₄×36.

Cape Cod Sunset. 1934. Oil. 28⁷/₈×35⁷/₈.

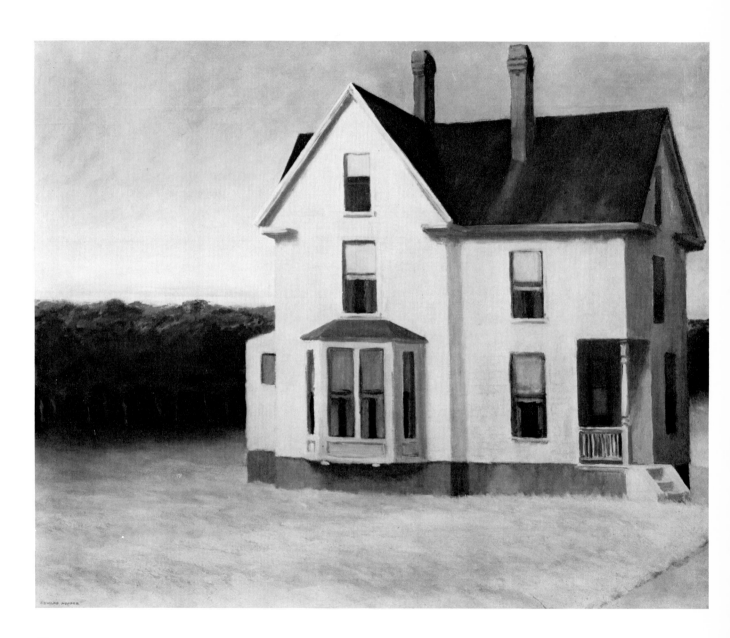

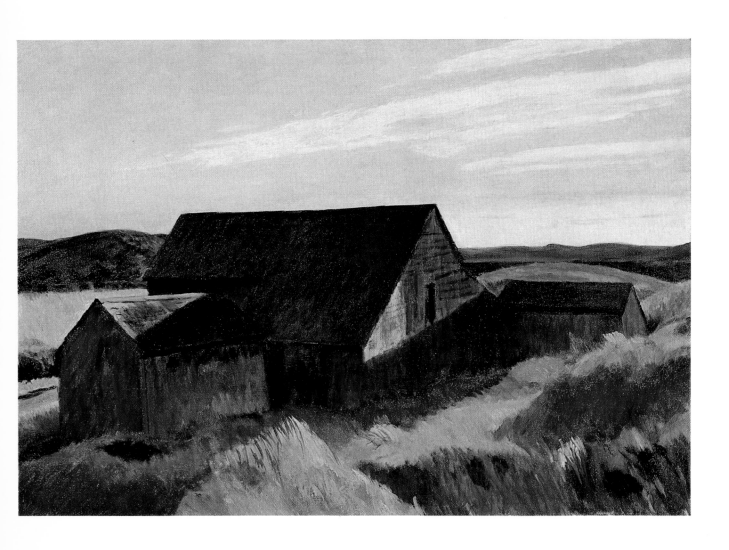

Cobb's Barns, South Truro. Probably 1931. Oil. $28^1/_2 \times 42^3/_4$.

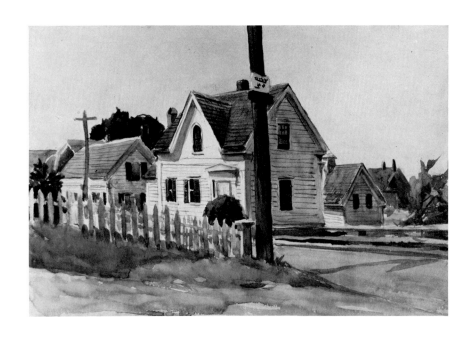

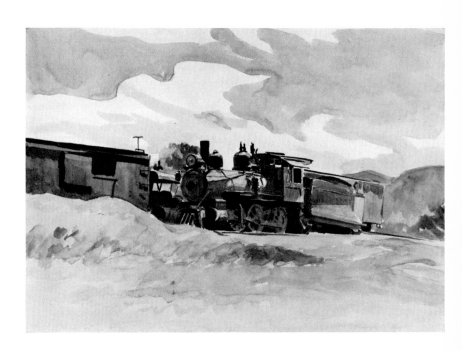

above: *White House with Dormer Window.*
Watercolor. 11³/₄×18
right: *Locomotive and Freight Car.*
Watercolor. 13⁷/₈×19¹⁵/₁₆.

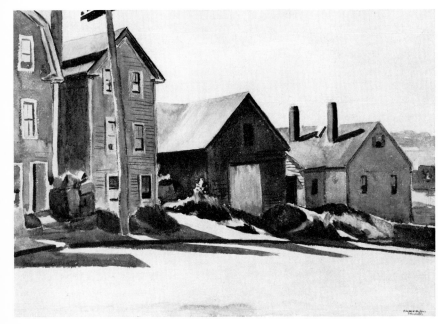

left: *Gloucester Houses*. Watercolor. 13⁷/₈ × 19¹⁵/₁₆.
below: *Village Church*. Watercolor. 19⁷/₈ × 25.

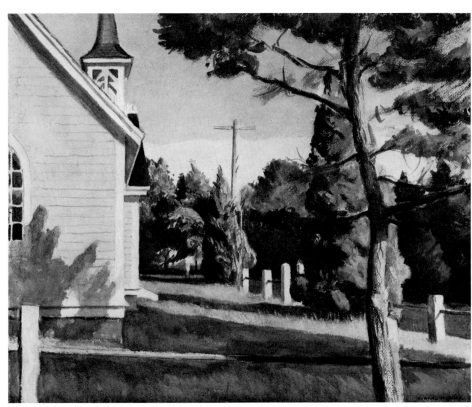

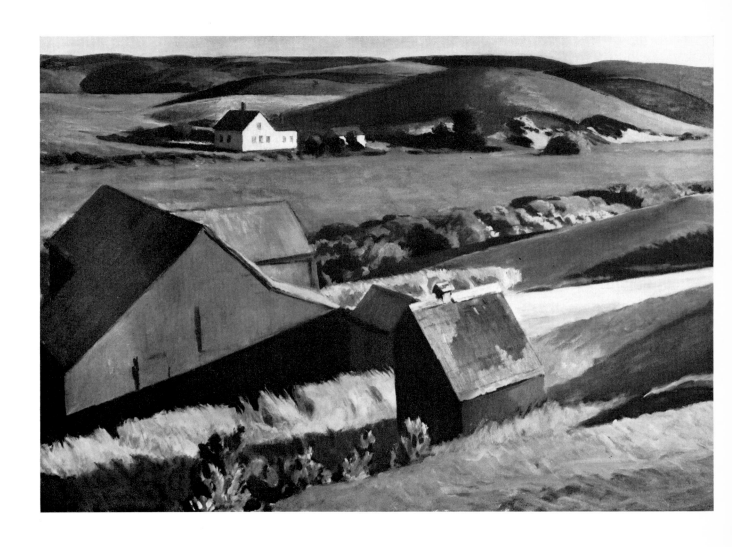

Cobb's Barns and Distant Houses. Probably 1931. Oil. $28^1/_2 \times 42^3/_4$.

Road and Houses, South Truro. Oil. 27 × 43.

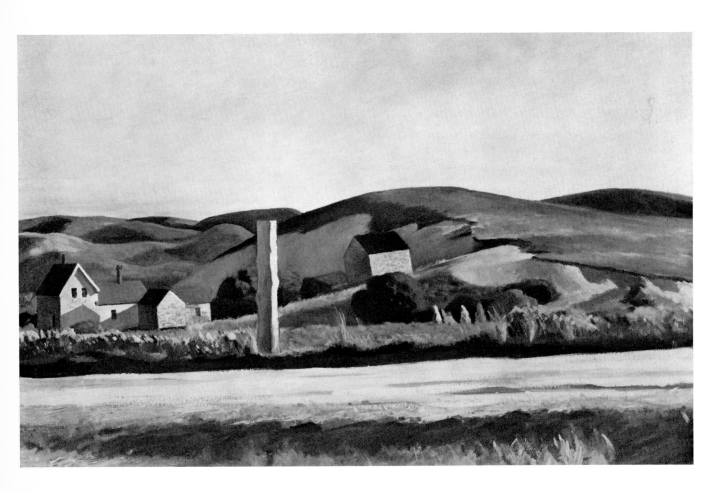

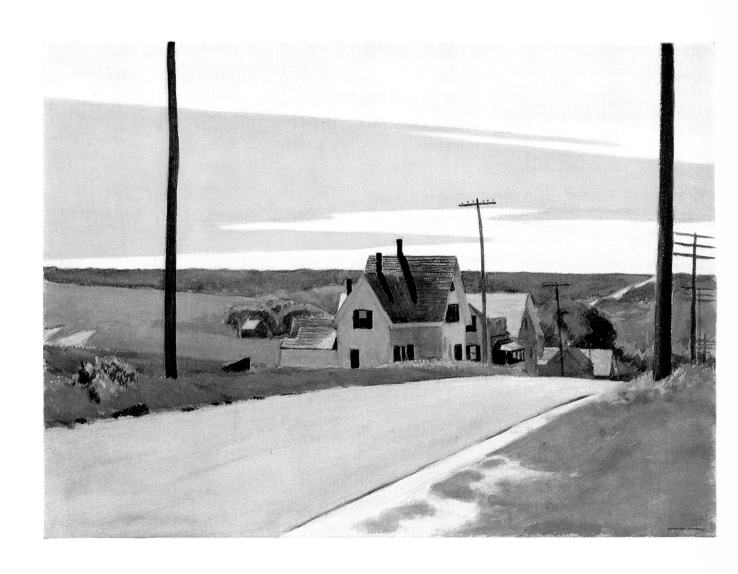

High Road. 1931. Watercolor. 20 × 28.

Longnook Valley. 1934. Watercolor. 20×28.

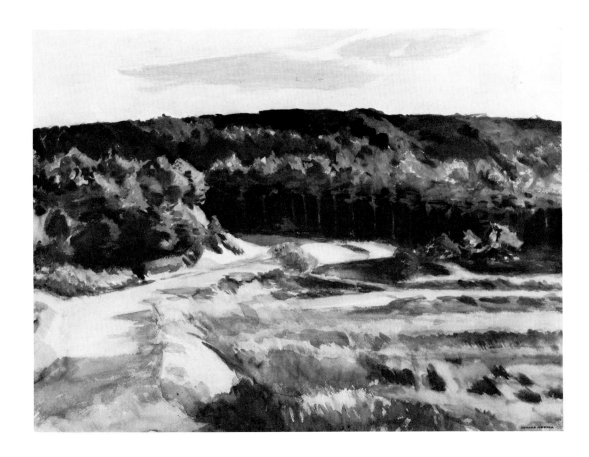

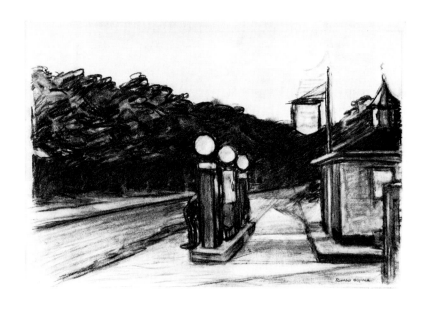

above: *Drawing for painting Gas.* 1940. Conte and
charcoal with touches of white. 15×22¹/₈.
right: *Drawing for painting Cape Cod Evening.*
1939. Conte, charcoal and pencil. 15×22¹/₈.

56

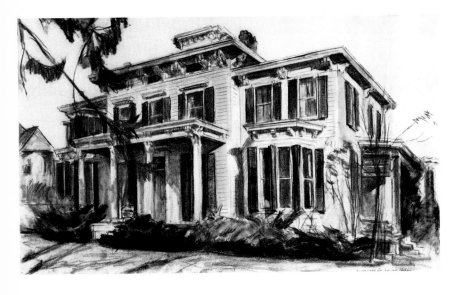

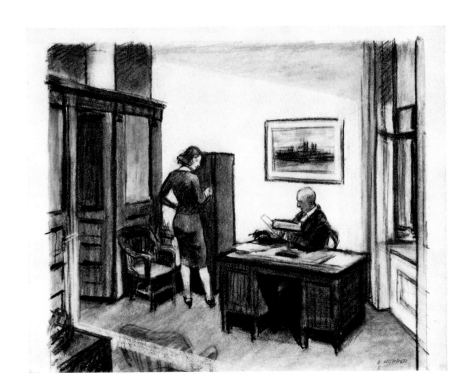

above: *Drawing for painting Pretty Penny.*
1939. Conte. $15^1/_{16} \times 25^1/_{16}$.
right: *Drawing for Office at Night, No. 1.*
1940. Conte and charcoal with touches of
white. $15 \times 19^5/_8$.

Roofs, Saltillo. Probably 1946. Watercolor. 21×29.

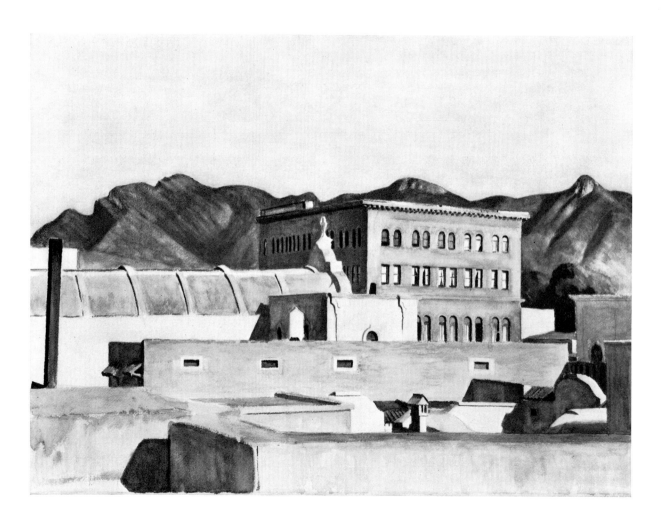

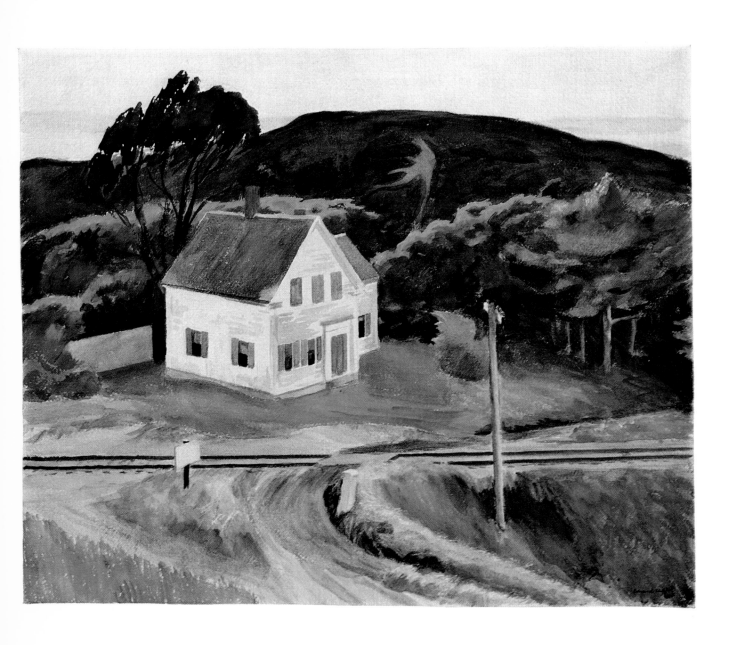

Capt. Kelly's House. 1931. Watercolor. $20 \times 24^7/_8$.

right: *Slopes of Grand Teton.* July 1946.
Watercolor. $13^{15}/_{16} \times 20$.
below: *Jo in Wyoming.* July 1946.
Watercolor. $13^{15}/_{16} \times 20$.

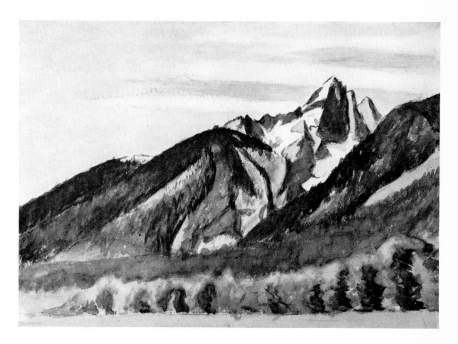

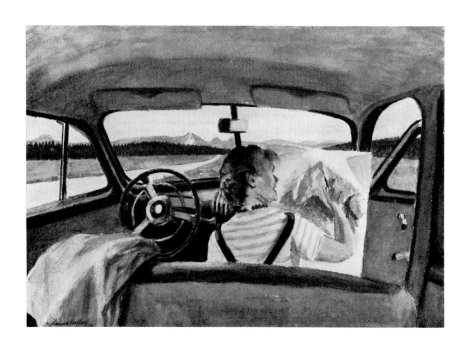

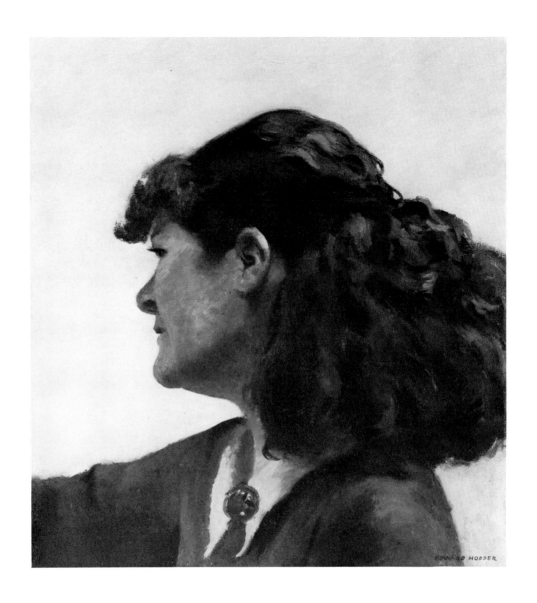

Jo Painting. 1936. Oil. 18×16.

Catalogue

Works are arranged chronologically within each medium. Those works, which cannot be placed chronologically are listed alphabetically by title at the end of each group. A dagger (⁺) indicates a descriptive title applied by the Museum to works which Hopper did not title himself. An asterisk (*) indicates works which will be exhibited at the Whitney Museum only.

Dimensions are in inches, height preceding width. All oils are on canvas, unless otherwise noted, and all watercolors, drawings and prints are on paper.

OILS

1. *Painting Class.*⁺ 22×18¹/₄.
*2. *Building in Paris.*⁺ Oil on wood. 1906/7 or 1909. 13×9¹/₄.
3. *Canal at Charenton.* 1906/7 or 1909. 23¹/₄×28¹/₄. *Ill. p. 18.*
4. *Canal Lock at Charenton.* 1906/7 or 1909. 23¹/₄×28³/₈. *Ill. p. 27.*
5. *Gateway and Fence at St. Cloud.* 1906/7 or 1909. 23×28.
6. *Les Lavoirs à Pont Royal.* 1906/7 or 1909. 23¹/₄×28¹/₂. *Ill. p. 23.*
7. *Louvre and Boat Landing.* 1906/7 or 1909. 23×28¹/₄.
8. *Louvre in Thunderstorm.* 1906/7 or 1909. 23×28³/₄.
*9. *Notre Dame #2.* 1906/7 or 1909. 23×28¹/₂. *Ill. p. 21.*
*10. *Paris Stairway.*⁺ Oil on wood. 1906/7 or 1909. 13×9¹/₄.
*11. *Paris Street.*⁺ Oil on wood. 1906/7 or 1909. 13×9³/₈.
*12. *Pont du Carrousel and Gare d'Orléans.* 1906/7 or 1909. 23¹/₄×28¹/₄.
13. *Pont du Carrousel in the Fog.* 1906/7 or 1909. 23¹/₄×28¹/₄.
14. *River Boat.* 1906/7 or 1909. 28×48. *Ill. p. 24.*
*15. *Trees in Sunlight, Parc du St. Cloud.* 1906/7 or 1909. 23⁵/₈×28³/₄.
*16. *Le Pont des Arts.* 1907. 23¹/₁₆×28¹/₁₆.
17. *El Station.* 1908. 20×29.
18. *Tugboat with Black Smokestack.* c. 1908. 20×29. *Ill. p. 29.*
19. *Ecluse de la Monnaie.* 1909. 23¹/₄×28.
20. *Pavillon de Flore.* 1909. 23¹/₂×28¹/₂. *Ill. p. 25.*
*21. *Le Pont Royal.* 1909. 23¹/₄×28¹/₂.
22. *Le Quai des Grands Augustins.* 1909. 23¹/₂×28¹/₂. *Ill. p. 17.*
*23. *Café Scene.*⁺ 36×72.
24. *Summer Interior.* 1909. 24×29. *Ill. p. 26.*
*25. *Blackwell's Island.* 1911. 24×29.
26. *American Village.* 1912. 26×38. *Ill. p. 30.*
27. *Italian Quarter, Gloucester.* 1912. 23³/₈×28¹/₂. *Ill. p. 28.*
28. *Tall Masts, Gloucester.* 1912. 24×29. *Ill. p. 37.*
29. *Gloucester Shorefront.*⁺ Probably 1912. 26×38. *Ill. p. 31.*
*30. *Queensborough Bridge.* c. 1913. 25¹/₂×37¹/₂.
31. *Cove at Ogunquit.* 1914. 24×29.
32. *The Dories, Ogunquit.* 1914. 24×29.
*33. *Road in Maine.* Probably c. 1914. 24×29.
34. *Rocks.*⁺ Probably 1914. 24×29. *Ill. p. 33.*
35. *Rocks and Houses, Ogunquit.* 1914. 23³/₄×28³/₄. *Ill. p. 32.*
*36. *Bluffs.*⁺ Oil on wood. 9¹/₂×13.
37. *New York Interior.* c. 1921. 24×29. *Ill. p. 34.*
38. *Railroad Crossing.* c. 1922–23. 29×39³/₄. *Ill. p. 40.*
*39. *Park Entrance.* c. 1923. 24×29.
40. *Railroad Sunset.* 1929. 28¹/₄×47³/₄. *Ill. p. 41.*
41. *Burly Cobb's House, South Truro.*⁺ Probably 1930. 24³/₄×36. *Ill. p. 47.*
42. *Cobb's Barns and Distant Houses.*⁺ Probably 1931. 28¹/₂×42³/₄. *Ill. p. 52.*
43. *Cobb's Barns, South Truro.*⁺ Probably 1931. 34×49³/₄. *Ill. p. 49.*
44. *Road and Houses, South Truro.*⁺ 27×43. *Ill. p. 53.*
45. *Cape Cod Sunset.* 1934. 28⁷/₈×35⁷/₈. *Ill. p. 48.*
46. *Jo Painting.* 1936. 18×16. *Ill. p. 61.*
*47. *Beached Boat.*⁺ 34¹/₂×59.
*48. *Stairway.*⁺ Oil on wood. 16×11⁷/₈.
49. *Self Portrait.* 25¹/₈×20¹/₄. *Ill. frontispiece.*

WATERCOLORS

50. *At the Café.*⁺ 1906/7 or 1909. 11¹³/₁₆×9¹/₂. *Ill. p. 20.*
51. *Woman.*⁺ 1906/7 or 1909. 11¹³/₁₆×9³/₈. *Ill. p. 20.*
*52. *1870–71: L'Année Terrible.* 19⁹/₁₆×14³/₄.
53. *L'Année Terrible: At the Barricades.* 21³/₄×14¹¹/₁₆. *Ill. p. 22.*

54. *L'Année Terrible: On the Rooftops.* 21³/₄×14³/₄. *Ill. p. 22.*
55. *New York and its Houses.* 21¹³/₁₆×14¹³/₁₆.
56. *Boy and Moon.*⁺ 21⁷/₈×14⁹/₁₆.
57. *Two Trawlers.*⁺ Probably 1924. 13⁷/₈×19⁷/₈. *Ill. p. 46.*
58. *Railroad Trestle in the Desert.*⁺ Probably 1925. 13¹⁵/₁₆×9⁷/₈.
59. *Building, Southwest.*⁺ Probably 1925. 13⁷/₈×19¹⁵/₁₆. *Ill. p. 39.*
60. *Coast Guard Station.*⁺ Probably 1927. 13¹⁵/₁₆×20. *Ill. p. 44.*
61. *Light at Two Lights.*⁺ Probably 1927. 13¹⁵/₁₆×20. *Ill. p. 44.*
62. *Light at Two Lights.*⁺ Probably 1927. 13¹⁵/₁₆×19¹⁵/₁₆. *Ill. p. 45.*
63. *The Battery, Charleston, S.C.*⁺ Probably 1929. 13⁷/₈×19¹⁵/₁₆. *Ill. p. 39.*
64. *Capt. Kelly's House.* 1931. 20×24⁷/₈. *Ill. p. 59.*
65. *High Road.* 1931. 20×28. *Ill. p. 54, cover.*
66. *Longnook Valley.* 1934. 20×28. *Ill. p. 55.*
67. *Roofs, Saltillo.*⁺ Probably 1946. 21×29. *Ill. p. 58.*
68. *Jo in Wyoming.* July 1946. 13¹⁵/₁₆×20. *Ill. p. 60.*
69. *Slopes of Grand Teton.* July 1946. 13¹⁵/₁₆×20. *Ill. p. 60.*
70. *Mass of Trees at Eastham.* July–August 1962. 21×28³/₄.
*71. *Back Street, Gloucester.*⁺ 13³/₁₆×20.
72. *Bell Tower.*⁺ 13¹⁵/₁₆×19⁷/₈.
73. *Blynnman Bridge.* 13¹⁵/₁₆×19¹⁵/₁₆.
*74. *Destroyer and Rocky Shore.*⁺ 13⁷/₈×19¹⁵/₁₆.
*75. *Farm Buildings and Cow.*⁺ 13¹⁵/₁₆×20.
76. *Fort and Gun.*⁺ 13¹⁵/₁₆×20.
77. *Gloucester Houses.*⁺ 13⁷/₈×19¹⁵/₁₆. *Ill. p. 51.*
*78. *Group of Houses.*⁺ 14×20.
*79. *House by the Sea.* 13¹⁵/₁₆×20.
80. *Locomotive and Freight Car.*⁺ 13⁷/₈×19¹⁵/₁₆. *Ill. p. 50.*
*81. *Outhouses.*⁺ 11³/₄×18.
82. *Pink House and Stone Wall.*⁺ 13⁷/₈×19¹⁵/₁₆.
83. *Reclining Nude.*⁺ 13⁷/₈×19⁷/₈.
84. *Rocks.*⁺ 13¹⁵/₁₆×20.
85. *Rocks and Cars.*⁺ 13⁷/₈×20.
*86. *Rocky Cove.*⁺ 13¹⁵/₁₆×20.
87. *Rocky Shore and Water.*⁺ 13¹⁵/₁₆×19¹⁵/₁₆. *Ill. p. 46.*
88. *Rooftops.*⁺ 12⁷/₈×20.
89. *Vermont Landscape.*⁺ 20×28.

*90. *Victorian House.*⁺ 13⁷/₈×19⁷/₈.
91. *Village Church.*⁺ 19⁷/₈×25. *Ill. p. 51.*
92. *White House and Telephone Poles.*⁺ 20×27⁷/₈.
93. *White House with Dormer Window.*⁺ 11³/₄×18. *Ill. p. 50.*

DRAWINGS

*94. *Dome.* 1906/7 or 1909. Conte, charcoal, wash and pencil. 21³/₈×19⁷/₈.
95. *On the Quai: The Suicide.* 1906/7 or 1909. Conte and wash with touches of white. 17¹/₂×14¹¹/₁₆. *Ill. p. 19.*
*96. *Cab, Horse and Crowd.* 1906/7 or 1909. Conte, charcoal and wash with touches of white. 18¹/₄×14⁷/₈.
*97. *The Railroad.* 1906/7 or 1909. Conte, charcoal and wash with touches of white. 17³/₄×14⁷/₈. *Ill. p. 19.*
*98. *Drawing for etching Evening Wind.*⁺ 1921. Conte and charcoal. 10×13¹⁵/₁₆. *Ill. p. 35.*
*99. *Drawing for etching East Side Interior.*⁺ 1922. Conte and charcoal. 8¹⁵/₁₆×11¹/₂. *Ill. p. 38.*
*100. *Drawing for etching The Henry Ford.*⁺ 1923. Conte and charcoal. 15¹/₈×18.
101. *Standing Nude.*⁺ October 26, 1923. Sanguine. 19×11¹⁵/₁₆.
*102. *Two Standing Nudes.*⁺ Sanguine. 22¹/₈×15¹/₁₆.
103. *Bending Nude.*⁺ Conte. 22¹/₈×15.
104. *Standing Nude.*⁺ Conte. 18×11¹/₂. *Ill. p. 42.*
*105. *Standing Nude.*⁺ Conte and charcoal. 22¹/₁₆×15. *Ill. p. 42.*
106. *Tree in Maine.* 1926, 1927 or 1929. Conte. 22¹/₈×15¹/₁₆.
*107. *Light at Two Lights.* 1927. Conte and charcoal. 15×22¹/₁₆. *Ill. p. 43.*
*108. *Drawing for painting From Williamsburg Bridge.*⁺ 1928. Conte. 8¹/₂×11¹/₁₆.
*109. *Topsfield.* 1929. Conte and charcoal. 15¹/₁₆×22¹/₁₆. *Ill. p. 43.*
*110. *Drawing for painting The Barber Shop.*⁺ 1931. Conte and charcoal. 12¹/₂×17⁵/₈.
*111. *Vermont—Shallows of the White River.* 1938. Conte and charcoal. 10¹/₂×16.
*112. *Drawing for painting Cape Cod Evening.*⁺ 1939. Conte, charcoal and pencil. 15×22¹/₈. *Ill. p. 56.*
*113. *Drawing for painting Ground Swell.*⁺ 1939. Conte and charcoal. 15×22.

*114. *Palace: Drawing for painting New York Movie.*[+] 1939. Conte. $4^1/_2 \times 7^1/_8$.

*115. *Globe: Drawing for painting New York Movie.*[+] 1939. Conte. $7^1/_4 \times 4^1/_2$.

*116. *Strand: Drawing for painting New York Movie.*[+] 1939. Conte. $7^1/_4 \times 4^1/_2$.

*117. *Drawing for painting New York Movie.*[+] 1939. Conte. $11 \times 8^1/_2$.

*118. *Drawing for painting New York Movie.*[+] 1939. Conte. $8^1/_2 \times 11$.

*119. *Drawing for painting New York Movie.*[+] 1939. Conte. $8^1/_2 \times 11$.

*120. *Drawing for painting New York Movie.*[+] 1939. Conte. $11 \times 8^1/_2$.

*121. *Palace: Drawing for painting New York Movie.*[+] 1939. Conte. $8^7/_8 \times 11^7/_8$.

*122. *Drawing for painting New York Movie.*[+] 1939. Sanguine. $11^1/_8 \times 15$.

*123. *Drawing for painting New York Movie.*[+] 1939. Conte. 15×11.

*124. *Drawing for painting New York Movie.*[+] 1939. Conte. $14^{15}/_{16} \times 11^1/_8$.

*125. *Drawing for painting New York Movie.*[+] 1939. Conte. 15×11.

*126. *Drawing for painting Pretty Penny.*[+] 1939. Conte. $15^1/_{16} \times 25^1/_{16}$. *Ill. p. 57.*

*127. *Drawing for painting Gas.*[+] 1940. Conte and charcoal with touches of white. $15 \times 22^1/_8$. *Ill. p. 56.*

*128. *Drawing for painting House on the Cape.*[+] 1940. Conte and charcoal. $15^1/_{16} \times 22^1/_8$.

*129. *Drawing for painting Office at Night, No. 1.*[+] 1940. Conte and charcoal with touches of white. $15 \times 19^5/_8$. *Ill. p. 57.*

*130. *Drawing for painting Office at Night, No. 2.*[+] 1940. Conte and charcoal with touches of white. $15^1/_8 \times 18^3/_8$.

*131. *Drawing for painting Route Six, Eastham.*[+] 1941. Conte and charcoal. $15^1/_{16} \times 22^1/_8$.

*132. *Perkins Youngboy Dos Passos.* 1941. Conte. 15×22.

*133. *The Artist's Hand (Three Views).*[+] 1943. Conte and charcoal. $22^1/_8 \times 15$.

*134. *Drawing for painting Rooms for Tourists.*[+] 1945. Conte and charcoal. $10^3/_8 \times 16$.

*135. *Drawing for painting Rooms for Tourists.*[+] 1945. Conte. $10^3/_8 \times 16$.

*136. *Drawing for painting Rooms for Tourists.*[+] 1945. Conte. $10^3/_8 \times 16$.

*137. *Drawing for painting Rooms for Tourists.*[+] 1945. Conte. $15 \times 22^1/_4$.

138. *Self Portrait.* 1945. Conte. $22^1/_8 \times 15$.

*139. *Carpenter's Plane.*[+] Conte and charcoal. $11 \times 15^1/_{16}$.

*140. *Docks and Boats.*[+] Conte and charcoal. $11^{13}/_{16} \times 18^1/_{16}$.

141. *Jo.*[+] Conte. $18^1/_{16} \times 15^9/_{16}$.

*142. *Road and Rocks.*[+] Conte. $15 \times 22^1/_{16}$.

PRINTS

143. *American Landscape.* 1920. Etching. $7^3/_4 \times 12^{15}/_{16}$. *Ill. p. 36.*

144. *House by a River.* 1920. Etching. $6^3/_4 \times 8^7/_8$.

145. *Train and Bathers.* 1920. Etching. $8^3/_8 \times 9^{13}/_{16}$.

146. *Evening Wind.* 1921. Etching. $6^7/_8 \times 8^1/_4$. *Ill. p. 35.*

147. *The Lighthouse (Maine Coast).* 1921. Etching. $9^7/_8 \times 11^{13}/_{16}$.

148. *Night in the Park.* 1921. Etching. $6^7/_8 \times 8^1/_4$.

149. *Night Shadows.* 1921. Etching. $6^7/_8 \times 8^1/_4$.

150. *The Catboat.* 1922. Etching. $7^7/_8 \times 9^7/_8$. *Ill. p. 36.*

151. *East Side Interior.* 1922. Etching. $7^7/_8 \times 9^{13}/_{16}$. *Ill. p. 38.*

152. *The Locomotive.* 1922. Etching. $7^7/_8 \times 9^7/_8$.

153. *The Lonely House.* 1922. Etching. $7^7/_8 \times 9^{13}/_{16}$.

154. *The Railroad.* 1922. Etching. $7^7/_8 \times 9^{13}/_{16}$.

155. *Girl on a Bridge.* 1922. Etching. $6^7/_8 \times 8^7/_8$.

156. *The Balcony.* 1928. Drypoint. $7^7/_8 \times 9^7/_8$.

157. *People in a Park.* Etching. $6^3/_4 \times 9^7/_8$.

66